THE
IN-BETWEEN
ARTIST

The Story of Tony D'Orazi

DAVID F. D'ORAZI

PAGE PUBLISHING, INC.
Conneaut Lake, PA

First originally published by Page Publishing 2020

ISBN 978-1-64701-752-1 (pbk)
ISBN 978-1-64701-753-8 (digital)

Printed in the United States of America

FOREWORD

Vince D'Orazi

I never really got to know my Grandpa Tony since he passed on not long after I was born. So, when my father asked me to edit the manuscript of the book he'd written about him, I looked upon it as an opportunity to finally get to know him.

Throughout my life, I've seen many pieces of my Grandpa Tony's artwork and heard stories about his days working for Walt Disney, as well as hosting his own TV show. I also heard about some of the challenges he faced from my father, but I didn't know the entire story. While editing this book, all of that would change, as I became enthralled with the tale of this first-generation Italian American who was seemingly born to create art but, along the way, encountered some tragic obstacles.

Throughout all of these struggles, however, my Grandpa Tony remained fixated on creating art. And now that he's gone, he's survived by his works, his family, and the inspiring story he's left behind which offers a look inside the soul of a truly talented twentieth-century American artist.

PREFACE

As Tony's son, I never really got to know my father while I was grow-ing up since he was either always busy working or dealing with the obstacles that life was presenting him with.

Before my mother Miltreta (also known as Treta) passed away in 2011, she entrusted me with all of my dad's journals and scrapbooks, which he'd been accumulating since 1932 when he was in his early 20s. This book is a product of those records that he kept during his life as well as historical documents, stories from within my family, and my memories of him.

Although the journey of assembling this book took several years, I savored every moment, as it finally allowed me the opportunity to *really* get to know my father even though he'd passed on decades ago. For me, being able to write this book was a gift, one that I am eternally grateful for.

My father's story proves that if you have an undeniable talent, you can successfully achieve any goals you set, no matter what hur-dles life might put in your way. And no matter how many times you get knocked down, you can always get back up and succeed again.

I would like to thank my son, Vince, for editing this book and my son, Ryan, for producing the artwork for it. Many of the photos you'll see within these pages were taken directly from my father's per-sonal scrapbooks as well as the D'Orazi family's personal collection.

I would also like to thank my wife, Beckie, for giving me the time away from home to write which I primarily did at "Treta's

Birdhouse," our cabin up in the mountains of Crestline, California, which I built as a tribute to my mom.

And finally, I must thank my mother for encouraging me to write this book.

PROLOGUE

The year was 1935 and although the entertainment world was currently in the midst of the "Golden Age of Cinema," having a radio in your home was currently the cheapest and most effective way to entertain an entire household.

In Hollywood, there lived a young artist by the name of Tony D'Orazi who dreamed of hosting his own radio show someday despite having a great job as an artist for an upstart animation studio called Walt Disney Productions. At the time, the project he was working on for Disney was set to be the first animated feature-length film in history—*Snow White and the Seven Dwarfs*.

Although he was happy with this current job on this historic project, it was still his dream to host his own radio show, teaching people to draw over the airwaves. After much perseverance, Tony's dream job was offered to him, and it was at that moment that he would be forced to make, what he called, "one of the biggest decisions of my life."

CHAPTER ONE

Early Life in Missoula, Montana

[1909–1912]

Tony's story begins twenty-six years earlier in the Western Montana town of Missoula. It was St. Patrick's Day, March 17, 1909, when Tony would draw his first breath outside of his mother's womb. Spring was on the horizon, but it was still rather chilly outside, as his parents Rose and John D'Orazi welcomed their first child into the world.

His parents had both immigrated to America from Italy in the late 1800s, and his mother, Rose, was a devout Catholic who attended church every day, rain or shine. As a result, she earned a reputation for being rather saintly, so it came as no surprise when she chose to name her firstborn son after one of her favorite Catholic Saints—Saint Anthony of Padua, who is also known as the patron saint of lost things, the one whom all Catholics fervently pray to whenever they need to find something they've lost. For his middle name, Tony's parents chose to honor John's father, Ambrose. And it just so happens that this name was also connected to another Italian Saint, and Antonio Ambrogio, as it would be pronounced in their native tongue, had a nice, Italian Catholic ring to it.

His mother Rose only stood a petite four feet and eight inches tall, whereas his father, "Big John," as he was often referred to, seem-

ingly towered over her with his six-foot-five-inch, 270-pound frame. John hailed from the town of Rimini, which is situated on Italy's Adriatic Coast, while Rose grew up a little over twenty kilometers away in the Republic of San Marino, which many technically still claim to be part of Italy, since, as the world's fifth tiniest country, it's surrounded on all sides by the boot-shaped country.

Upon arriving in New York from Italy, John found work as a blacksmith, which eventually led to him finding work on many of the bridges being built in the vicinity. He and Rose then decided to move west to Missoula, a town where many other Europeans and Italians had immigrated to, since they'd heard that there were plenty of opportunities for bridge builders like Big John there.

But Big John had bigger dreams than just being a simple bridge builder especially with a growing number of mouths to feed in his household. One night in 1913, while he was out playing cards with some of his Italian buddies that included some gentlemen by the names of Joe Gullo, Sam Bartello, and Giovanni Vitali, he found himself presented with an offer he couldn't refuse.

At one point in the evening, Giovanni, who'd likely had a bit too much to drink, offered to sell Big John three businesses that he owned: a bar, a market, and a hotel, which all occupied a single building in Missoula. His asking price—$500. Back then, that was quite a bit of money, and by today's standards (105 years later), that'd be about $13,000.

Unfortunately, John didn't have that kind of money lying around, but after thinking about the offer for a moment, he asked Giovanni, "If I can get you that $500 tomorrow, will you make the deal?" Giovanni agreed, and although Big John didn't have the money, he knew where he could get it—legally.

The next morning, Big John paid a visit to St. Francis Xavier, the local Catholic church that Rose attended mass at every day. Here, he met with the church's pastor and convinced him to loan him the

$500 to purchase the three businesses. Once under his direction, it didn't take Big John very long to whip all three of the businesses into moneymaking shape.

Eventually, everyone in town got to know Big John, and he became known for his signature look, which included blue farmer jeans, along with his well-groomed mustache, and suspenders that framed his big potbelly. He spent most of his time bartending but also played an active role in running the market and the hotel upstairs.

He managed to raise his family on the profits from these three businesses for many years, which was hard to keep up with, since he and Rose would eventually have eleven children (eight boys and three girls) together. And it would've been thirteen, but two of the children passed away during birth.

Although Big John had a limited education and primarily spoke Italian, he could carry a conversation on any topic with anyone. When he did speak English, it was with a very thick Italian accent. My father wrote in his journals about the times he would accompany his father to the produce supplier, where he would purchase the fruits and vegetables for the market. There, Tony recalls Big John asking, in his heavy Italian accent, "How much costa the vegetable today?" The supplier would then tell him the price, and Big John would give the go-ahead. "Okay, weigh 'em uppa!"

Although the market played a large part in helping Big John provide for his constantly growing family, the real moneymakers were the hotel and the bar. In fact, D'Orazi's Bar quickly became the most popular place to grab a drink in town, and the working-class types who frequented it loved that they could get a sixteen-ounce beer there for just ten cents.

Along with a bunch of rowdy Italian immigrants, the bar's clientele was a representation of Missoula's population at the time, which included everyone from lumberjacks, sheepherders, and rail-

road workers to farmers, politicians, doctors, and lawyers. And they all loved Big John.

Big John went to the bank every day to retrieve and deposit money, and when he did, he carried a loaded gun with him in a holster, since most times he'd have at least $1,000 on him in order to cash checks for the regulars that came to the bar. Not only could they drink their paychecks away at D'Orazi's Bar, but he would often cash his patrons' paychecks as well. It became a tradition that anyone who would get their check cashed at the bar had to buy everyone in the bar a drink, which made Big John even more money. Sometimes he let them run their tabs off their checks or even use the remaining balance of it on a room upstairs in the hotel. But that was a whole other story.

The hotel rooms that Big John operated upstairs from the market and bar were often rented to Italians who were tied to the local mafia as well as women working as prostitutes, and by the early 1920s, it had basically turned into a brothel of sorts. At that point, a teenage Tony and his brothers would take turns collecting rent from the hotel's tenants. And quite often, they would fight over whose turn it was since they all wanted to catch a glimpse of the ladies who resided up there.

As Tony described Missoula in his journals, "It was two rounded hills that met to form a canyon, and every winter the cold winds would howl through the canyon, sending everyone indoors." Perhaps that's what helped Big John's businesses become so popular as well, as the bar and hotel provided warmth to those who patronized them. In retrospect, it seems that the $500 gamble that Big John took on buying these businesses paid off, as they allowed him to provide a good life for himself, Rose, and their eleven children.

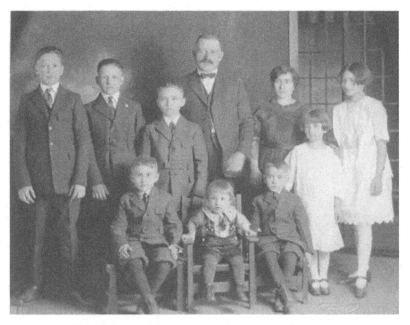

The D'Orazi Family (circa 1922). Standing: Tony (age 13), Joseph, Albert, Giovanni, Rosina, Ann, and Helen. Seated: Victor, John, and Ferdinand.

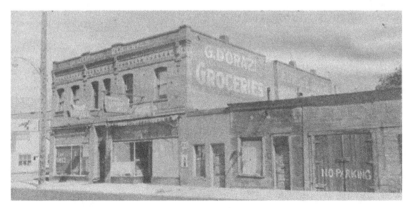

D'Orazi Groceries, Hotel, and Bar, located at the corner of Woody and Alder in Missoula, Montana.

CHAPTER TWO

An Artist Takes Root

[1913–1927]

Tony was only four years old when he first caught people's eyes with his artwork. One day, while hanging out with his dad at D'Orazi's Bar, he sat under a bar stool and created a drawing based off of a picture of a World War I battle scene that one of the bar's patrons had brought in. Even though Tony couldn't read yet, he was also able to precisely duplicate the printed words at the bottom of the picture onto his drawing.

The resulting drawing was astounding, and Big John proceeded to show it to everyone in the bar. The patrons were amazed, and at that moment, Big John knew that his son would be an artist. The drawing his son created that day in 1914 would continue to hang on the wall for many years at D'Orazi's Bar.

As his childhood years went by, Tony kept honing his skills as an artist and won multiple awards for his artwork within the community. But, of course, he had more learning to do, and since he was raised in an Italian Catholic household, it was imperative to his parents that their children attended a Catholic learning institution. As a result, Tony was enrolled at Loyola, a local Jesuit-run grammar school, and it was here where he started taking his art to the next level.

Aside from his love of art, Tony also loved having fun with his seven younger brothers and especially his brother, Joe. These two always seemed to be getting into trouble together whenever the opportunity arose. Tony recalled one instance where he and Joe took a gallon jug of wine from their father's basement, where he used to illegally make it during the bootlegging days of the 1920s Prohibition era. Well, the two of them polished off that jug and proceeded to have a grand old time, carousing the streets of downtown Missoula all night until the sun came up. They never got caught, or perhaps Big John just never said anything about it to them and just decided to let his boys be boys.

Aside from causing trouble on occasion during his childhood, Tony also recalls his father having to deal with other troublemakers as well. On one particularly beautiful Sunday morning, when Tony was ten years old, the family was returning home from church, at St. Francis, in Big John's car. When they pulled up in front of their house on Pine Street, Tony noticed one of his father's friends, Cillano, waiting at the front door, looking rather frantic.

Upon seeing the car pull up, Cillano raced over to Big John in the driver's seat but was so hysterical, he couldn't get the words out. Big John asked his overly emotional friend, "What da matter?" Cillano then told John that Giovanni just shot and killed one of his bartenders, Joe Thomas, in cold blood right in front of D'Orazi's Bar.

At that moment, John asked his wife to go into the house so he could speak to Cillano, but Tony and his brother, Joe, stayed with their dad and sat silently in the back seat, so they could hear the rest of the story. Eventually, however, their dad told them to get out of the car because he needed to go to the bar alone so he could get the whole story. When Big John arrived at the bar, his friend, Mike Peccha, filled him in on all the gruesome details, and ultimately, Giovanni was arrested for the shooting and charged with murder.

That's all Tony was ever officially told about the event, but since he was old enough to read the newspaper, he was able to follow the aftermath of the story. He eventually learned that Giovanni stood trial for the murder of Joe Thomas but then, somehow, and to everyone's surprise, was proven innocent and was set free. This was the first time in his life that Tony realized that who you know and what connections you might have can help you get away with a lot of things—including murder.

Tony was always fearful he may run into Giovanni again one day, but he never did. The cold-blooded killer was obviously tied to the mafia, and Tony didn't want to be involved in that world when he grew up. He knew that someday he wanted to leave Missoula behind in order to chase his dreams in the art world.

Before he spread his wings and flew away to somewhere else, Tony had to get through high school first. He continued his education at Loyola High School, where he also played a few sports but apparently didn't think he was very good at any of them. He mentioned playing football and baseball, but I never even found out my father played basketball until I was in my thirties, while we were on a trip to Missoula together. While walking around his old gym at Loyola, I noticed a photo on the wall of one of the school's championship basketball teams, and there he was. He admitted that he was a "fair" basketball player, but it was his brother Joe who was always known for being the athlete of the family. And that was okay by Tony.

Tony's main interest was always the arts. When locals needed posters or commercial art of any kind created, they enlisted Tony for the work. On one occasion, a local high school dance was being planned, so the school's dance committee held a meeting in De Smet, a suburb outside of Missoula, in order to discuss promoting the event. At the meeting, someone eventually suggested that a poster should be made to promote the dance and to ensure a sizeable attendance.

At that point, one young man on the committee shouted out, "Hey, get Tony D'Orazi to make the posters. He can't play football, but he's a real artist!" Tony was sitting just a few feet away and was a bit annoyed by the backhanded compliment he'd just received. So, he walked over to the bigmouth and said, "I'm a better man than you, no matter what I do." The young man stood up out of his chair and thrust his face close to Tony's. Everyone else on the committee thought there was about to be a fistfight, but there never was. The other kid backed down and never expected Tony, who wasn't good at football (in his opinion, at least), to be so tough.

As his high school career drew to a close, it seemed everyone knew Tony was a great artist. During his senior year, when it came time to put together his high school's yearbook, they called upon him to make it look good, as it was customarily filled with art of those in the graduating class, who were the best and brightest.

Students at Loyola had to actually be elected by their peers in order to have the honor of working on the yearbook, and Tony took the process seriously. He spent many long evenings, and even weekends, assembling his professional-looking portfolio, which was full of his best drawings, sketches, and cartoons he'd created up to this point of his young life.

Eventually, it came time to submit his portfolio to Ms. Roman, a teacher who served as the art director of the yearbook. Tony recalled her being very kind and encouraging about his offerings, however, she was sixty-eight years old and rather critical of his work. But when the final votes were tallied to determine who would work on the yearbook, Tony was far and away everyone's unanimous choice.

Looking back on this experience many years later, via a journal entry, Tony recalled the moment when the yearbook was published and released to his fellow classmates. He sat there admiring his work and thought to himself, "Some people just have it, and others don't," especially when it came to being an artist.

Another landmark moment of Tony's senior year came during a talent showcase he took part in at The Wilma Theatre in downtown Missoula. He recalls his father attending this event where, during his allotted time slot, Tony sang "Among My Souvenirs," which was a contemporary tune of that era that would later be covered by numerous singers of note, including Judy Garland, Louis Armstrong, and Frank Sinatra.

Tony had a truly great voice, but the highlight of his act came when he worked some "trick cartoons" for the crowd. These "tricks" included transforming letters of the alphabet and written words into pictures by adding a few simple strokes and also by creating optical illusions where the crowd would see two different images in the same drawing, sometimes by simply viewing it from a different angle.

At the end of this showcase, Tony received an award for his talents, and Big John knew that once his oldest child's high school career was complete, he needed to send him off to a college where his artistic gifts could flourish.

After being praised at this talent showcase, Big John asked his son what he wanted to do after high school, and Tony told him he wanted to continue to study and create art at the most renowned art school in America at the time—The Art Students League of New York. Located right off near Central Park in New York City, the Art Students League was known for having world-renowned artists as instructors and was also very influential in creating many movements in the art world.

It was at this time that Tony decided that his goal in life was to surpass another artist who was made famous by painting the ceiling of a church—Michelangelo. His masterpiece was the mural he painted on the ceiling of the Sistine Chapel at the Vatican in Rome over four centuries earlier, and Tony always admired his work.

It was now time to take his art to the next level, and he felt that attending the Art Students League of New York would set him off on

the upward trajectory he so deeply desired. Big John took Tony on a trip to New York to visit the school, and later that year, after graduating high school with multiple honors, he sent his firstborn away to chase his dreams of becoming a world-renowned artist, whose work would live well past his earthly exit.

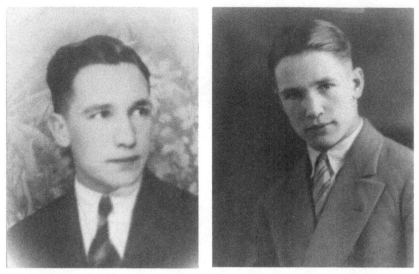

Tony in 1925 (age 16) *Tony in 1927 (age 18)*

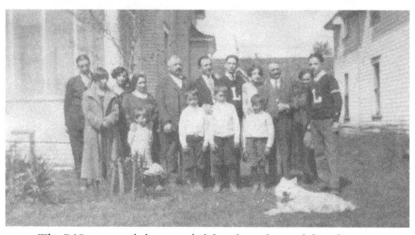

*The D'Orazis and the extended family in front of their home on
Pine Street in Missoula (circa 1926). Tony, age 18, fifth from
the right in the back row in his Loyola High School sweater).*

CHAPTER THREE

New York City

[1927]

In the fall of 1927, Tony left the countryside of Missoula for the bright lights of New York City, and during his first year of study at the Art Students League of New York, he chose to reside at a YMCA in Manhattan so he wouldn't break his budget.

The Art Students League of New York was known for having some of the world's best artists as instructors, and this was a major factor as to why Tony wanted to attend this school in the first place. Two of the teachers who made the biggest impact on him were Charles Dana Gibson and George Bridgman.

Charles Dana Gibson was formerly a student at the League, who later became a notable graphic artist and was famous in the art world for his pen-and-ink illustrations known as "The Gibson Girl," which he created from the 1890s through the 1910s. These images would become an iconic representation of the beautiful and independent American woman at the turn of the twentieth century, and many still claim that these images he created set the first national beauty standard for women in America.

However, George Bridgman was, by far, Tony's favorite instructor. Known for being one of the world's greatest living figure drawers at the time, Bridgman taught anatomy for artists at the school

and had even recently taught Norman Rockwell in the years before Tony arrived. Even at that time, the majority of classes at the school were for modern art, which was all the rage with its abstract and experimental approaches at the time, but what appealed to Tony was that Bridgman's class was the only one that truly represented what he called "real art." Even though there was pressure put on Tony to pursue his craft along the more modern route, Tony chose to stick with the classics at that moment.

Tony recalled a memory from one of Bridgman's figure drawing classes, in which he instructed his students to draw a nude female model who was seated before them. While the model was holding her pose, Tony noticed that she was crying but couldn't understand what was causing the tears. Still curious after class, Tony approached the model and asked if she was okay. She then revealed that, while holding the pose, she'd started her period and was bleeding onto the stool she was seated on, but she wasn't allowed to take a break, since Mr. Bridgman wouldn't allow it. This experience ultimately made Tony realize that this learning institution and its instructors took art very seriously and wouldn't accept anything less than complete dedication from its instructors, students, and models alike.

Drawing the human figure is what Tony excelled at, as did his idol, Michelangelo. Tony was so good at it that his work was compared by many of his teachers and classmates to Michelangelo's, especially how he was able to draw exquisitely detailed human figures and especially their hands. Tony actually became obsessed with trying to surpass Michelangelo's ability to draw such amazing hands. He would later write that it drove him crazy that he could never match Michelangelo's perfection, and when it came to his artistic endeavors, Tony always strove to be perfect.

His first year of studying at the League was a tremendous success, and once the school year finished, Tony moved back to Missoula for the summer. Here, he'd spend time with his parents and siblings

while also earning some extra money to take back to New York City, when he had returned for his sophomore year in the fall.

Although they were still in the midst of the Prohibition era, D'Orazi's Bar was able to remain open due to the help of some of Big John's "connections" in Missoula's Italian community. So, while he was home for the summer, Tony tended the bar at his dad's establishment during the daytime while also continuing to hone his craft by teaching art classes in the evenings.

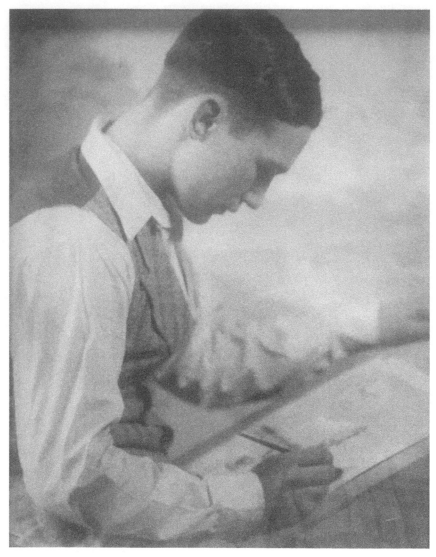

Tony, while attending art school in New York City (1927).

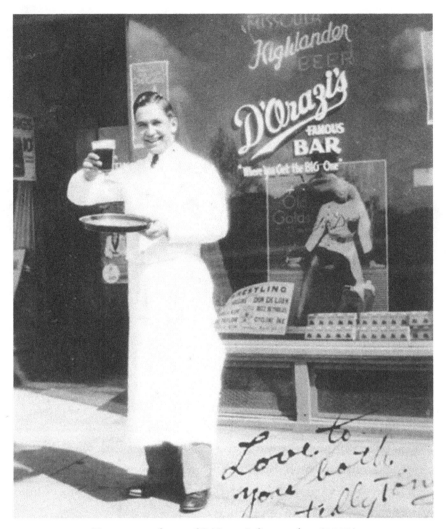

Tony out in front of D'Orazi's famous bar (1928).

CHAPTER FOUR

A Life-Changing Year

[1928–1929]

When the summer ended, Tony returned to art school for his second year, but this time around, he was heading back with a full scholarship to cover the entire year's tuition. Once again, he chose to live at the YMCA near campus, and during his second go-round at the League, Tony's instructors and peers came to view him as a bit of a phenom. He excelled in the mediums of drawing, painting, and sculpture, and at the age of nineteen, Tony became the youngest student ever elected to the school's board of directors.

Then, one night would turn Tony's life upside down. As he writes, one evening, he was out at a bar in Manhattan, when he was approached by two men, both of whom he assumed to be businessmen, since they were well dressed. They offered to buy him a couple drinks...and that's all he remembers.

Looking back, Tony assumed they must've "slipped him a Mickey," which at the time was a term used for lacing a drink with drugs meant to incapacitate someone, because the next memory he had after meeting the two men was waking up not knowing where he was—naked, alone, and confused in a New York City hotel room the following morning. Once he put it all together in his mind, he

realized that the two strangers had sexually abused him in this room he awoke to find himself in.

Traumatized and feeling rather delirious, Tony managed to be taken to a local hospital where, for the first time in his life, he was diagnosed with a psychiatric disorder. From there, he was committed to the mental ward at Bellevue Hospital in New York City.

After receiving news of this, his father, Big John, flew to New York from Missoula to retrieve his oldest child so he could bring him back home to begin his recovery under the watchful and loving eyes of his family. And with this, Tony's studies at the Art Students League of New York had suddenly and unexpectedly come to an end.

Tony in New York City (1929).

CHAPTER FIVE

The Comeback

[1929–1933]

Upon arriving back in Missoula, Tony once again took up residence at his family home that he grew up in. While he was here, Big John's brother, William (a.k.a. "Billy") D'Orazi played a large part in assisting Tony's recovery. "Uncle Billy" was a psychologist at a local hospital and had experience dealing with patients who suffered from mental disorders that resulted from suffering a traumatic experience, like his nephew, Tony, just had.

Eventually, after being back in Missoula and recovering for six months, Tony finally began to get back to a normal everyday routine. It was also the first time, since he prematurely had to leave New York City, that he began to create art again. Shortly thereafter, he began teaching art classes locally at the University of Montana as well as night school courses at a nearby high school.

Then in 1931, now age twenty-two, Tony enrolled at the University of Montana and was back on track to get his degree as an art major. While studying at the university, he was also asked to paint a mural on the ceiling of St. Francis Xavier, his family's church, which was the same one that his father, John, had initially borrowed the $500 from so that he could buy his now-booming businesses. The circular mural, which measures six feet and ten inches in diam-

eter, features the eight American Jesuit martyrs praying before an ascending Jesus and still remains on view in the church to this very day, almost a full century later.

That same year, Tony's younger sister, Helen, at age twenty, married a man by the name of John Kennedy, who was a local high school teacher and football coach in Missoula. However, one week after she'd married, tragedy unexpectedly struck, as she was diagnosed with pneumonia, and only one week later, she passed away.

In the aftermath of his sister's death, Tony was inspired to create what would become his most acclaimed work—a pencil drawing which he titled "The Death of Helen." At the bottom of the black-and-white drawing lies Helen's deceased body, while in the space above her hovers Jesus who holds a key in his hand. Above Helen's body, her spirit is pictured being raised from it, as she reaches for the key. Jesus appears to be pulling her up into heaven, into the clouds above, where she's met by seven cherubic angels who are all welcoming her to paradise.

Now twenty-three years old, and having just earned his degree, Tony was ready to dive back into the art world. After graduating, he decided to move to Chicago for a year so he could attend and submit his artwork to the world's biggest cultural event at the time—the 1933 Chicago World's Fair.

With its theme, "A Century of Progress," the fair celebrated Chicago's centennial, and as *The Chicago Tribune* described it, it was a place where people who were "then still mired in the malaise of the Great Depression could glimpse a happier not-too-distant future, all driven by innovation in science and technology." Fair visitors from all over the world witnessed the latest wonders in household technologies, rail travel, automobiles, architecture, art, and even cigarette-smoking robots.

Not only did Tony want to experience and absorb all the art on display, but he also wanted to enter his artwork into some of the

contests being held in conjunction with the fair. He brought along a portfolio of some of his best work, and one day at the fair, he encountered a pair of Catholic priests whom he showed his religious-themed pieces to.

They couldn't believe how good they were. They asked Tony if he was entering them into any of the contests at the fair, and he told them that he'd absolutely love to, but unfortunately, he didn't have the ten dollars (which would be around two hundred dollars today) that was required to enter. Without needing to convince them any further, the two priests gave him the money to submit his two pieces of art, one of which was titled "The Creation of Man," while the other was the tribute to his late sister, "The Death of Helen." Eventually, they both would end up winning first prize in their specific categories.

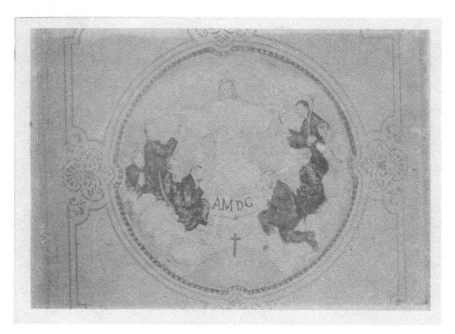

Mural of Jesuit martyrs at St. Francis Xavier
Church in Missoula, Montana (1931).

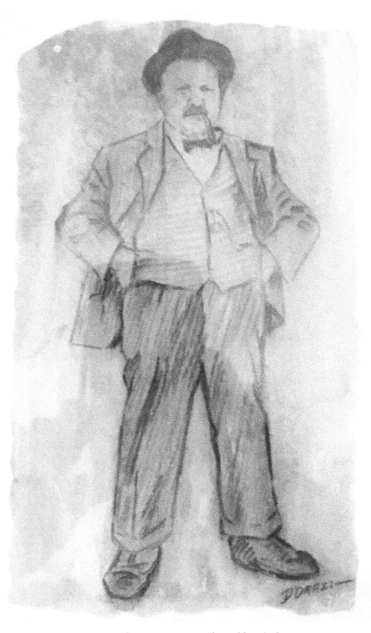

Tony's drawing/watercolor of his father,
Giovanni, a.k.a. "Big John" (1929).

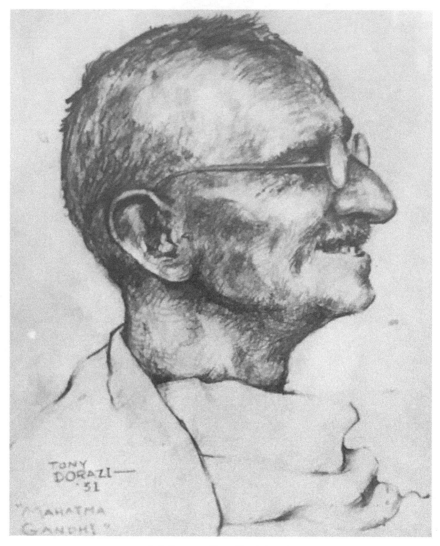

Mahatma Gandhi (1931).

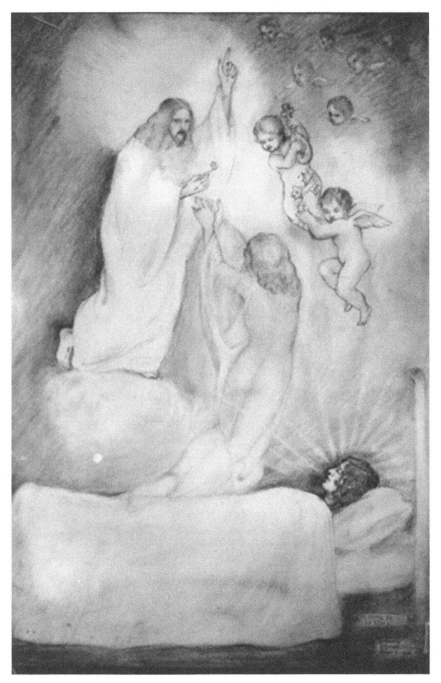

The Death of Helen (1931).

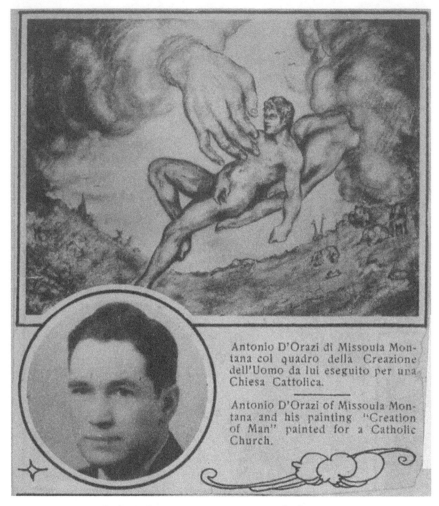

Italian American newspaper article featuring
The Creation of Man *(1931).*

WORK FOR MILK FUND—Miss Josephine Borrelli, president of the South Shore Junior League, and Tony D'Orazi, noted Montana artist, as they decorated The Herald and Examiner's Free Milk Fund booth at the World's Fair.

Clipping from a Chicago newspaper (1933).

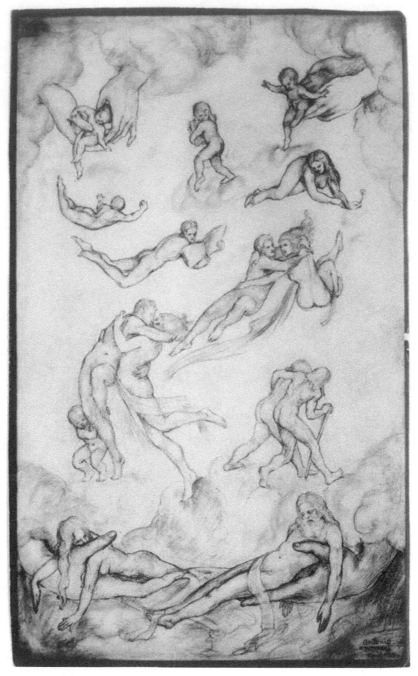

A work of Tony's, depicting Birth, Love, and Death (1933).

CHAPTER SIX

The Golden Age of Radio

[1933–1935]

Shortly after winning accolades at the World's Fair, Tony got a job teaching art in Chicago. However, he didn't find it very fulfilling, because what he really wanted was to teach art to a much larger audience by becoming the host of his own radio show. At the time, America was in the midst of the "Golden Age of Radio," and back then, having a radio in your home was the cheapest way to entertain an entire household. By 1934, sixty percent of homes across America had one, and a half-million cars were also now equipped with them as well.

In the fall of 1933, Tony met with the programming director at WGN Radio in Chicago and pitched him a concept for a show, in which Tony would teach kids how to draw cartoons over the airwaves. At first, the director couldn't quite wrap his head around how this would work, since drawing is a visual art, whereas the radio wouldn't allow listeners to see what was going on in the recording booth.

In order to prove his concept was bona fide, Tony whipped out a piece of paper and a pencil for the programming director and proceeded to verbally instruct the program director how to draw a detailed cartoon. In the end, Tony's determination paid off, and he was offered a time slot to do his show at the station. Now, at age

twenty-four, his dream of having his own radio show was coming to fruition, and for the next couple years, *The Tony D'Orazi Show* would steadily gain popularity throughout the midwestern United States.

During his time in Chicago, Tony also met a woman whom he would eventually get engaged to. They even set a wedding date, but then they broke up, and she became so distraught that she committed suicide. In my father's journal, I found an obituary notice with a picture of this woman whom he was supposed to marry. Oddly enough, she resembled his future wife, my mother, Miltreta, whom he wouldn't meet until years later.

His ex-fiancée's death shook Tony and caused him to want to leave the memories of her and Chicago behind. As a result, in 1935, he caught wind of an opportunity down in Hollywood, working for a new, up-and-coming animation studio known as Walt Disney Productions.

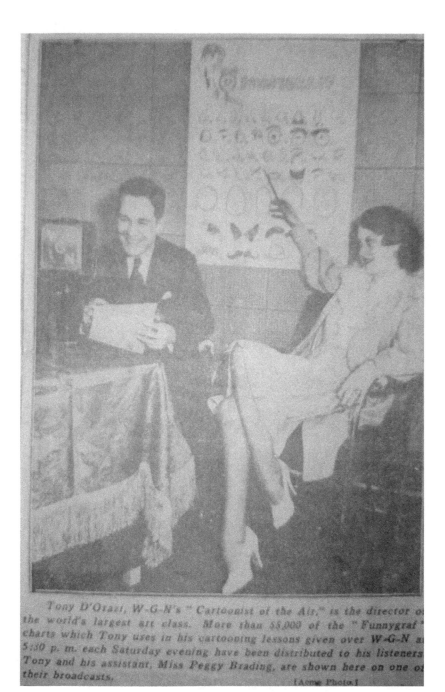

Tony D'Orazi, W-G-N's "Cartoonist of the Air," is the director of the world's largest art class. More than 55,000 of the "Funnygraf" charts which Tony uses in his cartooning lessons given over W-G-N at 5:30 p. m. each Saturday evening have been distributed to his listeners. Tony and his assistant, Miss Peggy Brading, are shown here on one of their broadcasts.

[Acme Photo]

Clipping from a Chicago newspaper (1934).

Promotional shot from a Chicago newspaper (1934).

CHAPTER SEVEN

Headfirst into Hollywood

[1935]

Disney had posted a classified ad in the newspaper, saying that they were looking to hire an "in between artist." Also known as "inbetweening," this term was used to describe the artists who would generate the frames of animation between two key frames in order to give the appearance that the first image flows smoothly into the second. Tony thought this seemed right down his alley.

He wrote that he took a southbound train to Los Angeles, and along the way, his mind drifted off as he gazed out the window at the sunny skies and swaying palm trees. Upon arriving in Hollywood, he reveled at the grandeur of its opulent scenery. As was customary with Tony, when he arrived in a new town, he took up residence at the local YMCA. Once he got settled, he knew inside that this was exactly where he needed to be and that he would enjoy this new chapter of his life which was about to begin.

When it came time to apply for the "inbetweener" position at Disney, Tony quickly discovered that they weren't just going to hand him the job. Apparently, there were over one thousand applicants, but there were only four positions they were looking to fill. After the screening process was complete, Tony was told that he and three others had made the cut and were offered a contract to come aboard

for a four-week trial period after which they would either be offered a longer contract or cut loose.

He was thrilled to get the opportunity, and during this month-long trial, Tony would be paid ten dollars a week, and every day, he and the other applicants were asked to draw from live nude models in order to help define and sharpen their skills of creating complex forms with simple lines. The head of the internal training and orientation classes at the Walt Disney Productions animation at the time was Don Graham, who was known for establishing many of the principles that became the foundations of the animation process that Walt Disney would be made famous for.

Legendary Disney animator Art Babbitt would later describe Graham in his memoirs, writing, "Don't really knew what he was teaching, and he 'showed' you how to do something—he didn't just talk. He taught us things that were very important for animation. How to simplify our drawings, how to cut out all the unnecessary hen-scratching amateurs have a habit of using. He showed us how to make a drawing look solid. He taught us about tension points, like a bent knee, and how the pant leg comes down from that knee, and how important the wrinkles from it are to describe form. I learned a hell of a lot from him!"

Tony truly benefitted from Don's lessons during that four-week-long period, and when the trial run was over, he and the other three hopefuls were screened once again. In the end, Tony passed their test with flying colors and was offered a contract that would pay him $37.50 per week. He was thrilled to be given this opportunity with an up-and-coming animation studio, but deep down, he came to Hollywood to create and get a big-time radio show of his own where he could continue teaching kids how to draw cartoons over the airwaves.

CHAPTER EIGHT

Snow White and the Golden Age of Radio
[1935]

The first project Tony was placed on at Disney was set to be the first animated feature-length film in history—*Snow White and the Seven Dwarfs*. Up until now, Walt Disney had only produced animated shorts and, at the time, making an eighty-minute-long animated film was seen as a major risk. Skeptics wondered if audiences would be willing to sit through such a lengthy film that didn't feature any actual humans. And since it wouldn't feature any actors on-screen, Disney wanted the animation to feel as real and as believable as possible.

So, Tony and the rest of Disney's animators would spend countless hours coming up with the look and movement of the film's characters. As Disney himself explained, "I put all my artists back in school. We were dealing in motion, movement, the flow of movement. Action, reaction. So, we had to set up our own school." Tony would help develop the character of Dopey for the film, and ultimately, Disney's big gamble paid off when, upon its release in 1937, it became the highest grossing film of all time. The animated movie would also change the face of filmmaking forever.

During his stint at Disney, Tony found out that the headquarters of KHJ Radio was only a few blocks from the YMCA he was

living at. At the time, KHJ was one of the "big four" radio networks in America alongside ABC, CBS, and NBC. They'd become well known, launching the careers of such notable performers like Bing Crosby, George Burns, and Gracie Allen.

Not about to give up on his dream of hosting an art-related radio show, Tony would go by the KHJ offices while he worked at Disney, and each time, he'd try to get past the receptionist in the hopes of meeting the program director so he could pitch him his show. He did this day after day for three weeks, but for some reason, he was always given, what he called, "the double shuffle," which made it tough for him to get his foot in the door. The way he saw it, the receptionist was the program director's guard dog, and no matter what he said or did, he couldn't get past her.

Then, one day, while Tony was leaving in defeat yet again, he headed back down the elevator, when a man standing next to him noticed he looked dejected and asked, "What's the trouble, sonny?" Tony turned to the noticeably unshaven man and told him the reason for his melancholy. "You see, I have a good idea for a radio show," Tony explained. "But that darn secretary up there won't let me in to see the program director."

"Well, I'm sorry to hear that," the man replied. "But here's what you need to do." Tony suddenly perked up. "Just come by the station next Monday morning, and tell the receptionist that you want to see Bill Goodwin. Tell her you have an appointment. She'll let you in."

Tony couldn't believe his luck, but he was supposed to be at work at Disney that following Monday morning, and although he really worked hard to get that "inbetweener" job, he decided it was worth it to go in late that day in the hopes of finally getting to meet with KHJ's elusive program director.

When that following Monday morning rolled around, Tony did exactly what the man in the elevator had told him to do, and before he knew it, he was stepping into Bill Goodwin's office. Upon enter-

ing, he was pleasantly surprised to discover that Bill Goodwin was actually the bearded fellow he'd met in the elevator the week prior.

Bill smiled at Tony as he entered his office and quickly got to the point. He asked Tony, "So, now just what is this great idea of yours?" Without hesitation, Tony explained how he'd taught youngsters to draw simple cartoons by giving instruction over the radio. To Tony's surprise, Bill immediately replied, "Well, that sounds like a great idea to me! Can you have a show ready by next Saturday?" Not even taking a moment to think about it, Tony answered with a resounding, "You bet I can!"

So, that following Saturday, Tony recorded his first radio show for KHJ in Hollywood. Almost immediately, the station started receiving tremendous feedback from listeners, and Tony's fan mail was soon plentiful as well. Although things were still going well with his job at Disney, Tony would now be forced to make, what he called, "one of the biggest decisions of my life."

Tony recalled that fateful day when he finally had to choose between staying at Disney or following his dream of hosting a big-time Hollywood radio show. "I remember that rainy day at the Disney offices," he wrote. "It was about two o'clock in the afternoon when I grabbed my raincoat off the coat rack and was approached by Mr. Drake." Mr. Drake was his supervisor and was wondering where Tony was heading off to, so Tony proclaimed, "I'm heading over to KHJ to do my own radio show."

As opposed to sharing Tony's enthusiasm, Mr. Drake put a damper on things by forcing Tony to decide, at that very moment, whether he wanted to work at Disney or be on the radio. They expected their animators to focus solely on their jobs and didn't want them having any other business-related distractions. Now buttoning his raincoat, Tony told Mr. Drake, "I choose the radio show." And Tony turned his back on Disney and stepped out into the rain to follow his dream.

CHAPTER NINE

Riding the Radio Waves

[1935]

The time had arrived, and Tony readied the script for his first episode. He chose to title the show, *Uncle Tony O'Dare: The First Cartoonist of the Air.* After this first episode aired, the positive feedback from listeners began, which made the programming director extremely happy.

As the weeks rolled by, Tony worked with many different radio announcers who were the "voices of the station" and would introduce his show on-air. Tony recalled that many of the announcers he worked with eventually went on to have big careers in television which, of course, didn't exist yet. One of these announcers was Bill Goodwin, who also served as the program director at the station. Tony described Bill as a bighearted human being, who had a magnetic personality and infectious smile. Tony believed that although most people could smile, they rarely use it to their advantage. However, even though it couldn't be seen over the radio, Tony considered Bill Goodwin's smile to be a key component of his success.

While producing his own show, Tony would also pen the scripts for the announcers to read during his broadcasts. Although he never took typing classes, he taught himself the "hunt-and-peck" system, in which the typist only employs one or two fingers to inexpertly find

the keys. He became very adept at this method and was actually very proud of this talent.

He recalls that during the early days of his show, he came up with a line of dialogue for the announcers to read while leading into commercial breaks. "Ah-ah-ah, don't touch that dial! Stay tuned for more with Tony O'Dare, the first cartoonist of the air!" Later, Tony discovered that Bill Goodwin ended up adopting this same phrase to use during *The Burns and Allen Show*, on which Bill served as an announcer and costar. That show was headlined by the now-legendary Hollywood duo of George Burns and Gracie Allen, whose program would go on to become one of the most popular radio shows of all time and was inducted into the Radio Hall of Fame in 1994.

Bill Goodwin would go on to achieve more fame in his lifetime not only as an announcer but as an actor and a comedian. For a while, he was the featured comedian on *The Frank Sinatra Show*, a radio show starring one of my dad's favorite singers of all time, "Old Blue Eyes" himself. Unfortunately, Bill would pass away in 1958 at the relatively early age of forty-seven.

"Uncle Tony O'Dare" headshot (1935).

CHAPTER TEN

An Artist in Love

[1935]

A few months into hosting his new radio show in Los Angeles, Tony was hired to entertain guests by performing trick cartoons at a political dinner dance. After his act, the dancing portion of the evening began, and he recalls what happened next.

"My eyes were focused on what looked to me like a living doll," he explained. "At first, she was dancing with a fellow who was much shorter than she was." Fortunately for Tony, the dances that night would all be "tag dances," which allowed men to "tag" or tap the shoulder of any other gentleman in order to get a turn dancing with the lady they were dancing with. So, Tony "tagged the hell out of him" and proceeded to dance with this gorgeous young lady for most of the remainder of the evening.

Her name was Miltreta, or Treta for short, and she was there because her aunt Emma was responsible for organizing the event. Unfortunately, she was only visiting her aunt in Los Angeles and lived down near San Diego, in Solana Beach. Although she looked much older, she was only fourteen years old which was twelve years younger than Tony. When the end of the evening arrived, he asked Treta if he could get her phone number, but she told him that she'd

have to get her aunt's permission. Seeing that she'd hired him to perform at the event, he figured he might have a shot.

Tony was elated when Treta arrived back to give him her aunt's phone number, and the following day, instead of simply calling her, he located her aunt Emma's address in the local phone book and decided to pay Treta a visit so he could see her once again before she went back home to Solana Beach.

In the days that followed, he would become enamored with Treta, and since she had to return home soon, he hoped that he'd be able to spend weekends with her. However, this was proving impossible for him to do, since his radio show recorded on weekends in Hollywood. His feelings for her were beginning to grow so strong, that one day he walked into the KHJ Radio offices, and told the Program Manager, that he wanted the program to be originate in San Diego, versus Hollywood, since he was moving there. To his delight, they had no objection whatsoever and easily accommodated his request.

So, Tony was on the move once again, but this time, instead of chasing the career he loved, it was for the love of a woman. Luckily, he was able to take his dream job along with him as well, as he moved down the coast of California.

In his notebooks, he shared a poem he wrote about his true love, titled "My Miltreta":

My Miltreta, is so sweet-ah,
And so neat-ah.
When I see her, on the street-ah,
I am discreet-ah.
I salute she, and I greet-ah.
I repeat-ah,
She's so sweet-ah, and so neat-ah,
That it is really quite a feat-ah.

To intreat-ah to be mine.
I love her so, my Miltreta,
I never cheat-ah,
And before I'm obsolete-ah, I hope to wed,
This lovely creature,
Because I love her so, Oh! Oh! Oh!
My Miltreta!

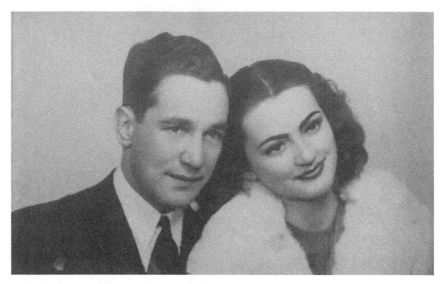

Tony and Miltreta (circa 1938).

CHAPTER ELEVEN

San Diego

[1935–1937]

For Tony, being able to spend more time with Treta instantly made his move down the coast to San Diego from Los Angeles well worth it. And it also didn't take very long for her family to fall in love with Tony as well. To them, he was a Hollywood star. Tony also didn't miss a beat when it came to broadcasting his radio show, as his radio show would make a seamless transition to the San Diego affiliate.

Shortly after his arrival, San Diego Gas and Electric became interested in Tony's radio show. Their reputation had been recently tarnished, as they'd been accused of overcharging customers, so they wanted to get Tony's help to change their image by helping them popularize Reddy Kilowatt, who was the company's cartoon mascot. Reddy Kilowatt was basically a stick figure whose body and limbs were made out of lightning bolts and whose round head had a light bulb for a nose and wall outlets for ears.

They initially signed him to a thirteen-week contract during which he'd promote the company, and he figured that they were happy with the job he did because they continued on as the main sponsor of his radio show for the next two and a half years. During that time, Treta also started to make guest appearances during Tony's radio program, performing the role of his "cartoon assistant."

While in San Diego, Tony also put together another radio show, which ABC Beer, a local brewery, sponsored. The twenty-six half hour-long episodes each focused on one of the "Old Masters," which was another term given to the "old master artists" whom Tony had great admiration for, such as Michelangelo, Rembrandt, and Botticelli. He also hired a local artist, Marjorie Richards, to help him write the scripts for the shows. In a nod to the program's sponsor, each episode ended with the announcer saying the name of the Old Master, followed by "…was indeed a great old master, and ABC Beer is the work of a great old master brewer."

Tony loved art and history, so he loved doing this show, and as he would tell people later on in life, it was his favorite job that he ever had. The show was successful, and Tony saved the scripts in the hopes that someday he would rewrite them for television, but unfortunately, he would never find the time to do it. As Tony wrote in his journals, "If life were only much longer, we could get so much done!"

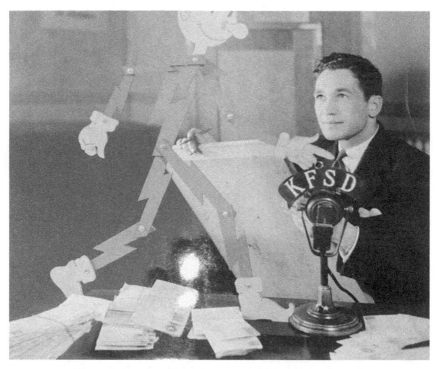

Tony observes Reddy Kilowatt at KFSD Radio (1935).

'Cartoonist Of The Air' Becomes San Diegan; To Exhibit Nov. 21

The Michelangelo of 1936 has come to San Diego.

At least, Dudley Crafts Watson of the Chicago Art Institute gives him equal billing with the Master.

Tony D'Orazi is the name and, contrastingly enough, he calls himself the "Cartoonist of the Air." You can hear him, if you like, on KGB at 4:15 p. m. today. Although his broadcasts originate in Los Angeles at present, he reports that KGB is planning to send them to the network from here in a few weeks.

❖ ❖ ❖

D'Orazi started drawing before he can remember. He knows this because his father has told him of the strange designs and pictures he used to scribble. Later, Tony won a school amateur show with a chalk-talk act and his father was so proud of him he sent him to art school.

❖ ❖ ❖

The lad broke into the press when, at the age of 18, he found himself honored for a mural he painted in his home-town church in Missoula, Mont. He started a scrapbook and it's been growing ever since.

❖ ❖ ❖

He had a whole wall in the Hall of Religion at Chicago's Century of Progress and that's when Mr. Watson gave Tony the build-up. Watson is quoted as saying of D'Orazi's work, "It is amazing. The knowledge of form and line is equivalent to Michelangelo. His

Tony D'Orazi . . . the cartoonist of the air, on KGB at 4:15 p. m. today, who will exhibit his murals at the Public Library Nov. 21.

work is most beautiful and extremely spiritual."

San Diegans will have an opportunity to see what pleased the art experts later this month, for beginning Nov. 21, he will exhibit at the Public Library, he said today. At present he is teaching cartooning by radio, and has been on the Don Lee network for nearly two years.

Clipping from a San Diego newspaper (1936).

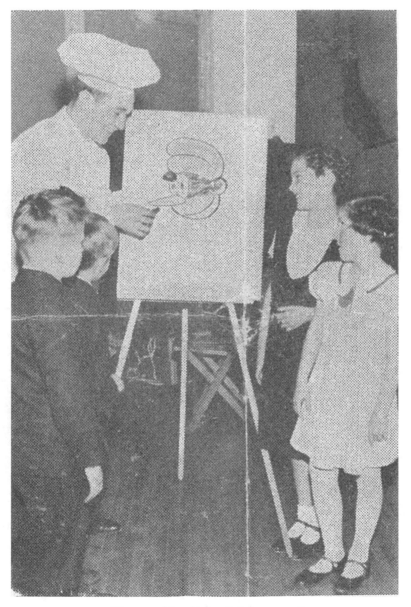

Tony teaching kids a "trick cartoon"
(Unknown newspaper, circa 1936).

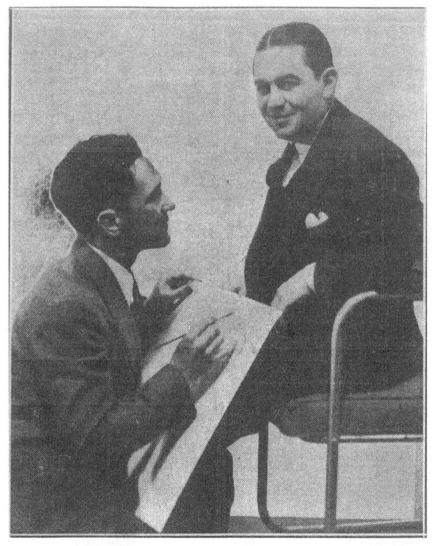

*Tony draws a portrait of jazz musician Jan Garber
(Unknown newspaper, circa 1936).*

CHAPTER TWELVE

A Partner for Life

[1938]

Tony and Treta waited until after she graduated from high school to get married, and on June 25, 1938, they finally tied the knot. Tony then decided it was time to leave his radio show in San Diego behind so that he and Treta could travel the United States to perform a vaudeville act that Tony put together, which combined his cartoon routines along with some singing and dancing.

Treta's stage name was Linda Love, and although she was only seventeen years old when they began performing, she looked much older. Although America was still at the tail end of the Great Depression, their show was quite successful, and for over the next year, they would perform in thirty-seven different states across the country.

Then, in the spring of 1939, the duo discovered that they'd soon be welcoming their first child into the world. So, at the conclusion of their tour that fall, they packed up and headed back to Tony's hometown of Missoula where Treta would give birth to their first child, a son, in December of 1939. They named him Anthony Michael Angelo D'Orazi as a tribute to Tony's idol, Michelangelo, and as he grew up, he'd become known to most of those who knew him as Mike.

Once again back home, now at age thirty-one, married, and a father, Tony again returned to working at D'Orazi's Bar for the next several years in order to save some money for his growing family's next eventual move. In July of 1943, Treta gave birth to their second son, John Allen, who they named after Tony's father. John was born with encephalitis, which is an inflammation of the brain and is most often caused by a viral infection. As a result of this condition, the doctors told Tony and Treta that it was likely that John would never be able to walk. However, at the age of three, he miraculously took his first steps and started walking on his own shortly thereafter.

With John walking, it became easier for the family to make the move they'd been saving up for, so Tony started looking for a way to get back into the entertainment world, since in its absence, he'd come to miss it. Then, one morning, he came across an advertisement for a job opportunity at KPFY, a local radio station out in Spokane, Washington. It wasn't for an on-air position but for managing their advertising department. He figured that if he landed this job, he could likely work his way into getting his own show at the station as well, so after being offered the position, he packed up his wife and two sons and moved the family 200 miles west of Missoula to their new home in Spokane.

To supplement his income in Spokane, Tony also accepted a job, selling tires at a local tire store, but, of course, the job opportunity he was most excited about was the one at the radio station. It wasn't before very long that Tony, once again, was hosting his own radio show teaching people how to draw. But then something happened that would give Tony the itch to return to Hollywood. You see, a new invention was just starting to hit the mainstream—television.

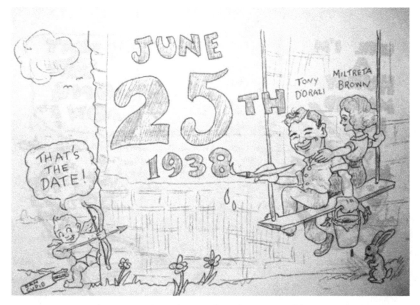

"Save the Date" for Tony and Miltreta's Wedding (1938).

"Save the Date," reverse side/front of trifold card (1938).

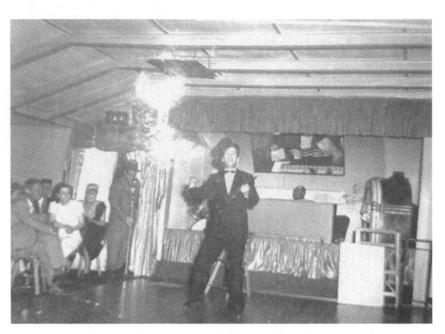

Tony performs a song and dance routine during one
of his and Treta's vaudeville acts (circa 1938).

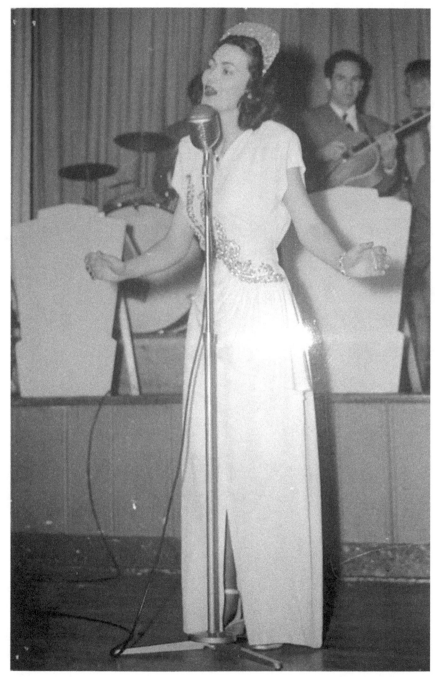

Miltreta performs during of the duo's vaudeville acts (circa 1938).

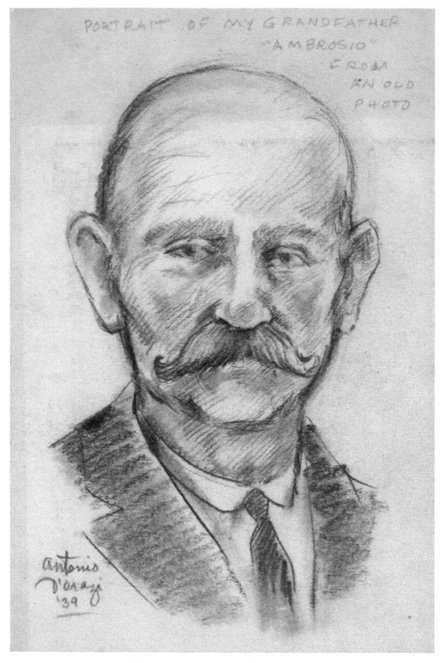

This is a portrait that Tony did of his Grandfather "Ambrosio," (1939).

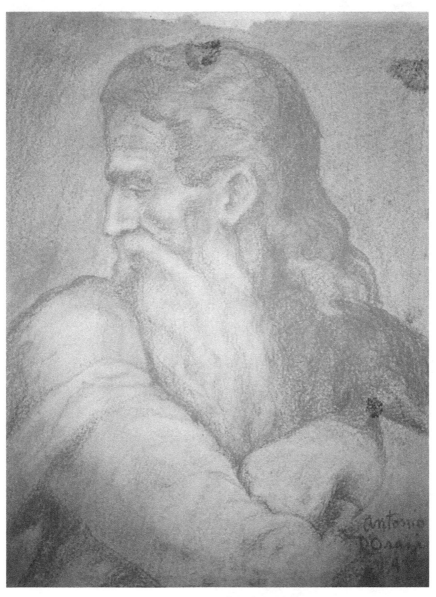

Tony's portrait of God (1943).

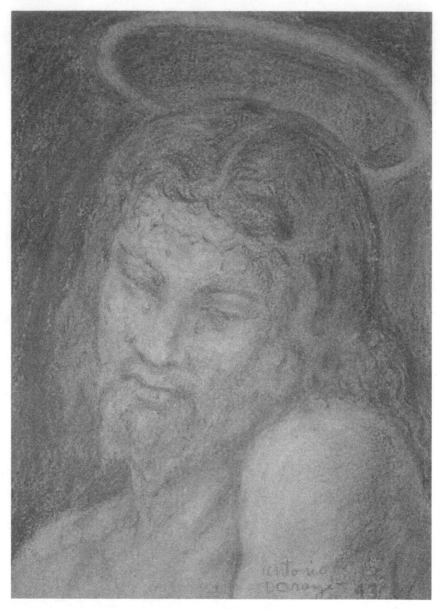

Tony's portrait of Jesus (1943).

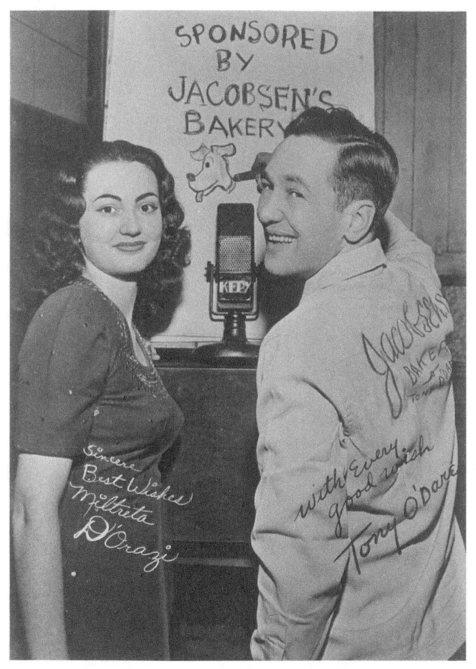

Miltreta and Tony, Spokane, Washington (1946).

CHAPTER THIRTEEN

The Dawn of Television

[1947]

In 1947, full-scale commercial television broadcasting began in the United States, and it was then that Tony decided to move his family to Los Angeles. They bought a home in the northeastern community of Eagle Rock. While Tony got back to doing his radio show, this time at KHJ Radio, he also returned to do some work for Walt Disney as an in-between cartoonist, but what Tony really wanted now was his own TV show.

Eventually, after much persistence, he was able to sell the local TV station, KTLA, on bringing his radio show to the TV screen. To put the show's new TV format together, he was teamed up with producer Phil Berle who was Milton Berle's older brother and was fresh off producing The Three Stooges film, *Jerks of All Trades*.

Then, in 1949, *Uncle Tony O'Dare: First Cartoonist of the Air* made his television debut and went on to become quite successful. For the next four years, Tony would earn high ratings for the network and also win numerous awards. Aside from kicking off his TV career in 1949, Tony and Treta also gave birth to their third child, another son, who they named David Ferdinand. Later on in life, I was told that I actually took my first steps on camera during one of my father's TV shows, sometime in 1950.

During these early days of local television, many on-air personalities would make public appearances to promote the station they worked for and their shows. "Uncle Tony" often made these appearances, and in 1952, he recalls that, after an appearance at a local supermarket, some kids followed him to his car. At the time, he was driving a beat-up green 1949 Ford two-door sedan. The kids, seeing Uncle Tony as a TV star, said, "Oh my God, Uncle Tony, is that your car?" Somewhat ashamed, the very next day, Tony went out and bought a brand-new red 1952 Buick Roadmaster with a white cloth top convertible, onto which he had his name, *Uncle Tony O'Dare: First Cartoonist of the Air*, painted in gold lettering on both sides.

Ultimately, his show would come to an end at KTLA in 1953, after Tony got into a big fight with Phil Berle, his producer, after which his show was cancelled. In the aftermath of the cancellation, Tony made efforts to return to TV and auditioned for the producers of *The Pinky Lee Show* in the hopes of becoming part of that successful variety show by doing his signature trick cartoons. Pinky Lee was a goofy man-child similar to how Pee Wee Herman was decades later, and Tony was anxious to impress the producers with his skills.

After performing over twenty minutes of his best trick cartoons during his audition, he picked up all the scattered sheets of paper he'd drawn upon from the floor and left. Tony had hoped to hear back from them soon, but instead, about two weeks later, Tony tuned into *The Pinky Lee Show*, only to see Pinky Lee himself doing the same cartoon tricks that he'd showed the producers during his audition. In his journals, Tony said he never quite forgave them for that audacity, but in the end, that's show business for you.

Now finding himself in need of another change of scenery, the family moved a couple of hundred miles north to Fresno where Tony was able to get himself another TV show at KMJ, which was

a station that recently opened there in town. His show was sponsored by Harvest Queen Bread and did well for its first year on the air. However, the sponsor would eventually drop out when it didn't renew his contract after the first year at which point the latest incarnation of Uncle Tony O'Dare would leave the airwaves.

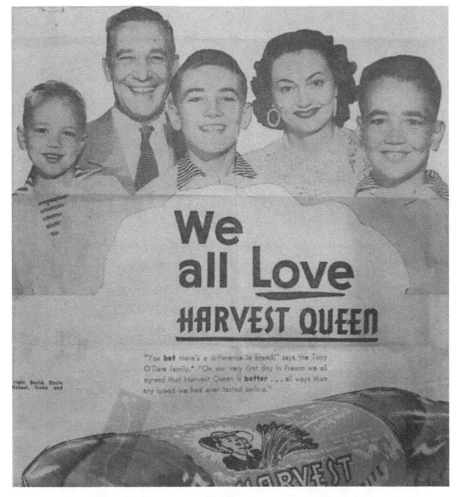

Advertisement for Harvest Queen Bread, featuring
Uncle Tony O'Dare and family (1954).

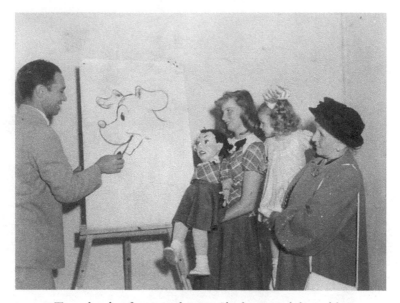

Tony sketches for ventriloquist Shirley Dinsdale and her dummy Judy Splinters, along with an unidentified woman and child. Shirley would go on to be the recipient of the first-ever Emmy Award [first award presented at the first ceremony] for Outstanding Television Personality (1949).

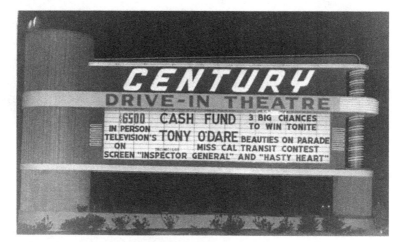

Century Drive-In Theatre Marquee in Inglewood, California (1949).

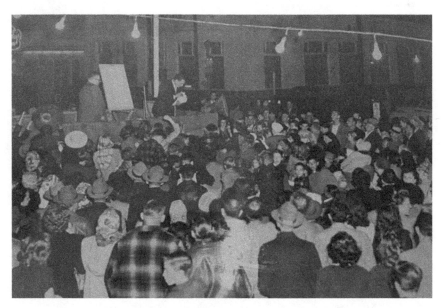

Tony performs for a crowd in the early 1950s.

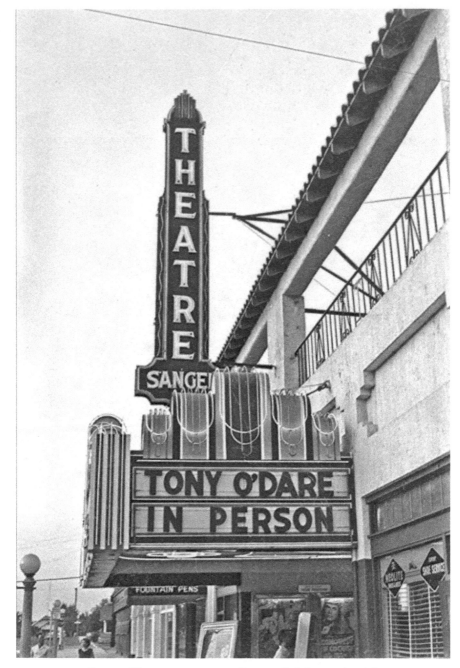

Sanger Theatre marquee in Fresno, California (1954).

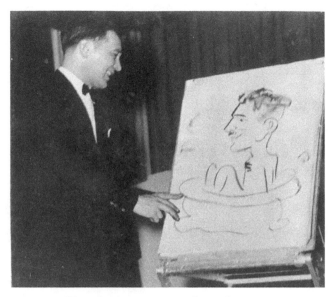

Tony draws onstage in the early 1950s.

Tony's passport photo (May 14, 1954).

CHAPTER FOURTEEN

The Art of the Sale

[1955]

Despite moving to Fresno a couple of years earlier, Tony and Treta held onto their house in Los Angeles and rented out while they were away. Then, in 1955, they decided to move the family back to their previous home in Eagle Rock. Once they were back, Tony tried to get back into the TV business and also went back into sales, this time, selling cars at local car dealers.

I remember my father, Tony, saying the car-selling business was a tough game. There was no union representation, so they basically worked for free and solely on commission. In fact, one month, Tony didn't sell a car, and he ended up owing the dealership fifty dollars for his demo car which they let him drive around town. The dealers were shady as well since they'd often find devious way to cut commissions whenever a car was sold. When that happened, the only thing Tony could do is leave that particular dealership and go work at another.

Fortunately, Tony and Treta were able to amass about thirty thousand dollars in savings over the years which helped the family get through those challenging times. Then one day in 1956, Tony's brother, Vic, called and hit him up to invest in a "big real estate deal" he was working on in Seattle. He was guaranteeing a twenty-percent return on their investment and eventually convinced Tony and Treta

to invest their entire life savings of thirty thousand dollars on the project.

Less than a year later, the deal went bad, and all the money was lost. Ultimately, Tony forgave his brother Victor for this, since it wasn't his fault the project had failed. As a result, money was tight once again, and our family literally ate chicken every night whenever my dad wasn't selling cars. At that time, a whole chicken cost thirty-nine cents a pound, and that's all we could afford. We even used to joke about how many different ways my mom could prepare chicken. In the end though, it all tasted good, and we were all just happy to have something on our plates.

The challenges continued for the family in 1956 when Tony and Treta were involved in a terrible car accident. They were "T-boned" at an intersection by another car which resulted in Tony hitting his head and injuring his leg. He initially lost his memory, and his knee needed to be wired back together as well. The trauma to his head also led to some major mental breakdowns which came to a head one night, as he was taken away in a straitjacket from our home in Eagle Rock. I will never forget witnessing that moment as a young boy.

For the six months that followed, he was committed to a mental hospital up in Camarillo, during which he received thirty-seven shock treatments in the hopes of returning him to a normal state of mind. During this period, my family and I didn't see much of my father. I remember visiting him one day at Camarillo State Hospital, and after six months, he got his memory back and returned home.

When he got back to the Eagle Rock house, I remember it being quite a strain on our family. He was considered manic at this point, which meant that he constantly swayed between high highs of excitement and low lows of depression. Often, when he was in a depressed state, there were times when he would go into his room and just sleep all day.

After six months of being back home, Tony gradually got back into creating artwork. Typically, whenever he was in his depressed state, he would go to bed at nine and get up at seven or eight. However, when he was in his manic "happy" state, he would go to bed at midnight and get up at three or four in the morning in order to go paint in his art studio behind our garage, which he dubbed "Cloud Nine."

At this point, painting had become a type of therapy for him, and he would paint for a couple of hours before anyone else in the family would wake up in the morning. During these middle-of-the-night sessions, he'd paint and repaint over existing paintings, depending what kind of mental state, or mood, he was in at that time.

When he was in his studio, he always played music, too, which was typically by one of his favorite singers like Dean Martin or Frank Sinatra. He would paint many different kinds of paintings, and their styles usually reflected his mental state at the time. So, as a result, some of these works were rather bizarre. Rarely would he paint landscapes or portraits, and oddly enough, he would never want to sign or finish any of these creations.

Sometimes it seemed like Tony never slept. Aside from waking before dawn to paint, he would also make all kinds of random phone calls in the predawn hours, which would understandably startle the friends and family he was spontaneously reaching out to. Many of them complained to Treta that his calls would wake them up at all hours of the night, and she'd tell them often that he had "phone-itis," which was a term she made up to describe his condition. Tony never thought twice about calling anyone at any time and also regularly called into local radio talk shows at all hours either to complain about modern art or to chime in on whatever topic in particular was being discussed that night, since he also seemed to be a bottomless pit of knowledge.

The reason he was knowledgeable on so many topics is because he loved to read and learn new things every single day. Tony was also a speed reader and could digest several books in a matter of hours. There were days when he'd go into his room and two hours later, he'd read twelve art books. Over the years, he also learned to speak four other languages aside from English—French, German, Italian, and Spanish.

Around the same time Tony began getting back into his artwork, a car dealer he'd previously worked for, by the name of Bob Smith, gave him his old job back selling cars. Throughout his numerous breakdowns he'd endured during his lifetime, they always seemed to have a job for him whenever he got well again. He loved selling and eventually became great at it. It wasn't long until the family was able to eat full meals again for dinner each night aside from just chicken.

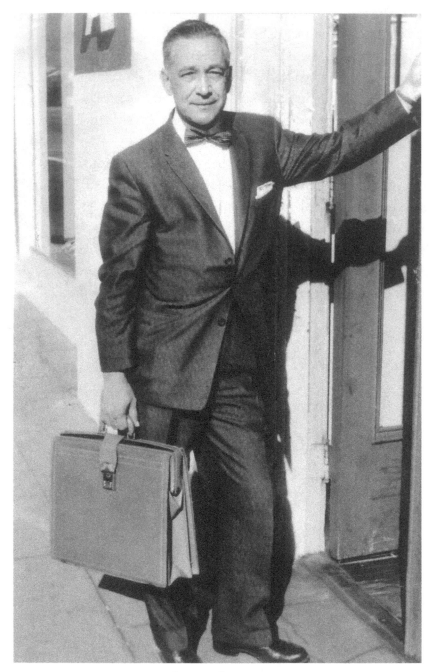

Tony, the car salesman (1963).

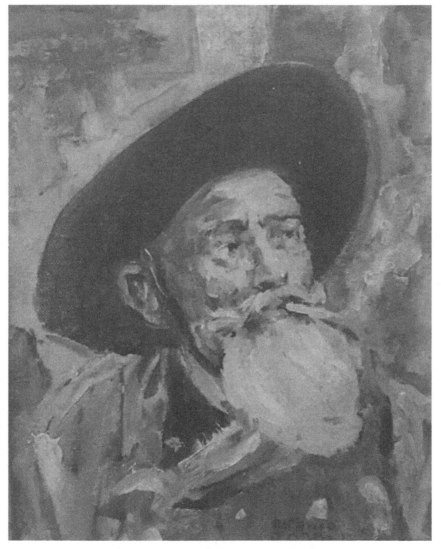

Tony's painting of a bearded man smoking (1956).

CHAPTER FIFTEEN

A Family Completed

[1957]

Now that his life and career appeared to be back on track, Tony wanted to fulfill a lifelong dream of his, which was to visit Italy. Not only did he wish to experience the land where his ancestors hailed from, but more importantly, he wanted to see some works of his hero, Michelangelo, with his very own eyes.

Finally, the time had come, and he scheduled his trip to Italy which was set to depart via steam ship from New York on January 11, 1957. It had been a long time since Tony wrote in his journals, but his excitement about finally getting to fulfill this dream of his spurred him to put pen to paper once again. "Here I go," he wrote. "I'm forty-seven years old, and gray hairs are scurrying to my temples. My health is good. I've always wanted to go to Italy, and by the grace of God, this time I will make it."

Ultimately, Tony would only get as far as New York, since he didn't like the idea of going to Europe all alone. So, he turned around and came back to California. "I was determined that next time, my wife Treta will come with me, and that will be much more pleasant," he wrote. Upon returning home from his cancelled trip, Treta broke the news to him that she was pregnant, and later that summer, she

gave birth to their fourth child—and first daughter—on August 27, 1957.

They named her Kathleen Rose, but she would go on to become known as Kathy. As a child, she became interested in acting, and during her teen years as a successful actress, she went on to adopt her father's stage name and became known as Kathy O'Dare.

In 1974, she appeared alongside Ron Howard on the cover of *TV Guide* in order to promote the premiere episode of the new TV series, *Happy Days*, which she appeared in. Many other notable roles would follow, including ones on *The Brady Bunch*, and *The Banana Splits Adventure Hour*. She also went on to star in a 1975 episode of *Bronk*, which featured Jack Palance and Mark Hamill, right before he landed his iconic role of Luke Skywalker in the *Star Wars* films. She would also reteam with Ron Howard for the 1976 Roger Corman film titled *Eat My Dust*. After retiring from acting in her late twenties, Kathy went on to have a daughter, who she named Miltreta, after her mother, before she would eventually pass away at age fifty-two in 2010.

CHAPTER SIXTEEN

Fifty Years Deep

[1959]

In the spring of 1959, Tony wrote, "I am now in my fiftieth year of manhood, and during my half of a century of life, I've had the questionable pleasure of being committed to a mental hospital a few times."

He continued to describe what it was like to live as a manic depressive. "Why is it, I ask myself, when I am in a so called 'upcycle' of my psychoneurosis, I always felt like a person under the influence of hypnotism? In the 'manic stage,' I get a firm conviction that my actions are not only correct, but they are infallibly perfect, right on the button, and I also feel that they have to be done at that very moment…period!

"There is a fervor and haste that be compared to the actions of one who is hurrying to complete his chores, because he knows that in a short while, he will be dead. And yet, months later, I sit and meditate in retrospect, and I see myself, while in one of these upcycles, as a person magnifying the importance of every single minute detail, event, and decision. While in this state, everything has to be completed according to spur-of-the-moment decisions. It grows from the fervor itself no matter what I am doing."

Tony knew what it was like to feel hypnotized since he'd studied it in his earlier years and even used to hypnotize people for fun at parties. The way he described his mental illness in his writings offers insights into his ups and downs and the impulsive nature of his decision-making, which often led to some unpredictable situations coming to pass.

On one occasion, Tony randomly decided to attend a Sunday morning service at an all-black church service in Watts. This was during an era when no white man in his right mind would even consider setting foot in that part of town. After the church service finished that day, Tony stuck around to meet some of the congregation and drew some cartoon caricatures of some of them in order to win them over. In the months that followed, he even put on an art show at their church. Aside from just this one instance, Tony loved all people no matter what color, race, religion, or sexual orientation they were. And they loved him right back. Especially when he was in his happy "high cycle" of his manic stage.

Another story I recall hearing was, one morning, while he was driving around, Tony saw an elderly Hispanic woman walking down the road whom he knew from their neighborhood. Since my dad spoke Spanish, he stopped and asked her, in Spanish, where she was going. She told him that she was heading to church, so he asked her if she wanted a ride. She happily obliged, so he drove her to church and even went inside for the service and sat behind her until he eventually fell asleep, which was a result of him not having slept a wink the night before.

Throughout all these ups and downs, Tony continued to be a successful salesman. During this time, he was setting sales records at the dealership and was making some good commissions too. He wrote that "the car-selling gig was still a tough game." For the first time in years, he was working a schedule that allowed him every other weekend off, to which he noted, "That's what I call living!" He

loved having free time, and as much as he loved spending time with his family, he also proclaimed, "The happiest moments of my life, for me at least, are those days when I can lie around and do exactly what I want to do."

I remember one time when I was a teenager, my dad, Tony, brought a new demo car home from work. It was a gorgeous, super-charged brand-new Dodge Charger, and he asked my friend, Greg, and I if we wanted to take a ride on the new freeway, the Highway 2 in Eagle Rock, that had just opened up. "Heck yeah" was our response, so we hopped into the back seat, and as we hit the on-ramp, my dad floored it. Once my friend Greg and I saw the speedometer hit 120 miles per hour, we both huddled down into the back seat and started praying, because we'd never gone that fast before and thought we might die as a result.

My dad Tony was fun when he was in his high/happy cycle, but the flip side could be rather troubling. I recall one morning when I was growing up, I returned home after delivering my paper route to find my father in an extreme state of fear. He thought someone, or something, was trying to get him. He was so freaked out, he even started trying to board up the windows and doors of our house. It was always from one extreme to the other with him as far as I can remember. Growing up with my dad was like a seesaw; it was a constant series of ups and downs.

Tony's headshot (late 1950s).

CHAPTER SEVENTEEN

A Man of Many Hats

[1961]

From an early age, Tony took on an affinity for wearing hats. During his vaudeville days, he would often wear a fedora or top hat, but now in the early 1960s, he regularly wore a mandarin cap, and he wore it all the time—when he was creating art and even when he wasn't. He said he always liked to wear it to keep his head warm and keep from getting a cold. Needless to say, Treta didn't love this look on Tony, so my mom bought him a new French beret for his birthday.

The day after receiving his new headwear as a gift, Tony recalled it being "a beautiful day in Eagle Rock, with its rolling hills, and beautiful blue skies." Wanting to plan an outing, he called his artist friend, Ernie Schrank, who lived nearby in Mount Washington. Tony had met Ernie during some art classes, which he took part in for fun, and the two artists became the best of friends.

Being in his early eighties, Ernie was a bit older than Tony. He was also around six feet tall, with a potbelly and slightly balding head. Tony asked if he wanted to join him to go see an exhibition of drawings of the human figure at the Huntington Library in San Marino that one lovely day. It was about a twenty-minute drive from Eagle Rock in San Marino. Ernie was happy to tag along, so Tony picked him up, and they headed out on their cultural expedition.

On their way to Huntington Library, the ever-impulsive Tony decided to make a pit stop. He told Ernie he had a surprise for him, as they parked in front of the Paul Metcalf Art Gallery, which was located along their route there. Noted for being an eccentric dresser, Tony remembered exactly what he wore that day. Aside from his new beret, he donned a cashmere sport coat, a pair of purple and black pants, and a pair of black sandals with no socks.

Upon opening the swinging glass door at the entrance, the pair of artists made a grand entrance, which caught the eye of the man and woman who were tending the gallery. Tony asked, "Can we look at your paintings for a few minutes?"

The woman smiled and said, "Of course you can, and perhaps you might even like to take home a painting or two?"

"No, I don't think so," Tony replied. "I'm just a car salesman, so I don't have a lot of money, but I do love painting."

Meanwhile, the elderly man, who was sitting comfortably beside the woman, started giving Tony the eye, as he began looking at the art hung on the gallery walls. One by one, as he went along, Tony would make comments on the pieces, such as "Nice color," or "Good depth." Then, at the sight of one piece, Tony stopped dead in his tracks. "A John Singer Sargent!" he proclaimed. Upon gazing at this work of an artist who was often referred to as "the leading portrait painter of his generation," Tony continued, "I must say, this one is really interesting, and I really like it!"

The seated man, who happened to be the proprietor, Mr. Paul Metcalf himself, finally spoke. "Are you an artist?"

"Well, I've been painting for many years, for my own amusement mostly," Tony replied. Then, commenting on the collection they had assembled at the gallery, Tony complimented the seated man. "I like these types of paintings you have here. Much more than the op, pop, and slop we're fed at the county museum."

That particular remark worked like a pep pill on Mr. Metcalf, and from that moment on, my dad said they chatted as if they'd known each other for decades. Ultimately, his and Ernie's pit stop lasted much longer than expected, and now they needed to get to Huntington before it got too late. Without hesitation, Tony invited the Metcalfs to come along, and the four of them were soon on their way. Once again, Tony was quick to win people over with his impulsiveness, wit, and charm.

One of the vivid memories I recall from this part of my dad's life is that he worked a lot, so I didn't get to see him as much as I'd have liked to. But he'd help me out with my paper route quite a bit, since he was often up at 4:30 a.m., which was when I'd wake up to start my route. He'd always tell me to leave my bike behind and let him drive me in his car to deliver the morning papers instead. How could I resist?

When he drove me on my route, I wouldn't sit in the passenger seat alongside him. Instead, I'd sit in the car's trunk, since it made it easier for me to wrap and toss the papers from there. I had to work fast too: fold each paper, put a rubber band around it, and toss it in each house's driveway. I'd do my best, but sometimes I couldn't keep up with his speedy pace, so I'd pound on the popped lid of the trunk to get him to stop. Sometimes he'd hear me and sometimes he wouldn't, or couldn't.

Then, we'd have to do the block all over again, with me hitting the ones I wasn't able to get on the first go-round. Looking back now, it's likely that he was cranking his music so loud that he couldn't hear me back there, and even though it was hectic at times, I truly appreciated any chance I could get to spend time with my dad.

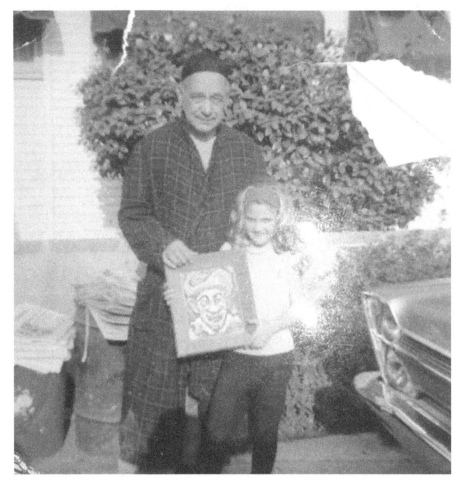

Tony (wearing his mandarin cap) stands with his daughter Kathy
outside of their home with one of his painted portraits (1964).

CHAPTER EIGHTEEN

A Son's Perspective

[1963]

Since the age of nine, I started working while also attending school. In my youth, I also always did my best to help my mom out in any way I could. And as my father and I grew older, she asked me to help her keep him under control. Especially when he would get into his really bad manic stages.

Since my oldest brother Mike was now off in the Navy, and my other older brother, John, was developmentally disabled, I now remained as my mother's obvious choice to help her handle my dad, whenever he would have one of his manic episodes. I often cried when I had to do it because it was extremely hard for me to negotiate with my own father in such a state, but fortunately, he would often end up listening to me and understanding why it would be best for him to get professional help. Quite often, this required him to commit himself to mental institutions.

I clearly remember one occasion. I was fourteen, and I awoke to some scuffling noises coming from my parents' bedroom, and I knew that my father was out of control. I barged into the room to see my frightened mother, so I stepped in and stopped my dad. The following morning, my mom asked me to drive him to Las Encinas

Hospital in Pasadena, where I was able to convince him to commit himself. He would spend the next two months in treatment there.

Upon returning home from this postbreakdown recovery stay at the hospital, Tony wanted to start selling something different. Something other than cars. Ultimately, he decided he wanted to try his hand at real estate instead. Treta had always wanted for Tony to try it, since many of his brothers did well in real estate as did some of her aunts and uncles. Even Treta's own mother made some big money, buying and selling property during a time when real estate was mostly a man's game.

The thing about my mother is she always believed in my father. She also truly, really believed that my dad could sell anything, no matter what it was. But unfortunately, it didn't take long for Tony to realize that he didn't have the necessary patience to be a real estate agent. What he didn't like about it was that it required taking clients around and showing them house after house, since most of the time, they took quite a long time to make up their minds. Plus, interest rates were going up, which prevented a lot of folks from buying real estate at the time. This literally drove my dad crazy, since he loved to make the quick sale and not drag things out. Ultimately, the life of a real estate agent wasn't for Tony, and after a year in the industry, he decided to return to selling cars.

Aside from working back at the car dealership, Tony also supplemented his income by working for a company that sold personalized calendars, keychains, pens, Christmas cards, and other types of novelty items, and also sold ad space in the local Eagle Rock yellow pages.

He had a knack for sales aside from real estate apparently; he was typically able to make some decent income for the family over the years, especially after losing his and Treta's life savings after the failed investment opportunity which had happened less than a decade earlier.

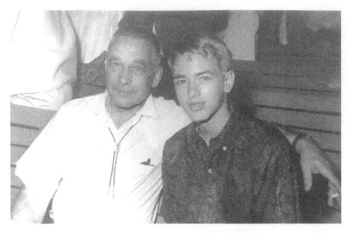

Tony and his son, David (1964).

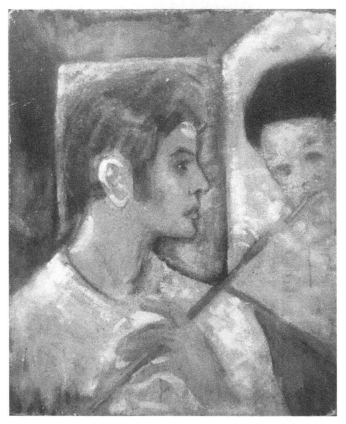

Tony's painting of David creating a portrait of his father (1966).

CHAPTER NINETEEN

The Many Personalities of Tony

[1965–1967]

A decade after losing Tony and Treta's life savings, his brother Vic tried making amends by giving my family a bright red 1963 Plymouth Valiant convertible. I recall my mom and sister enjoying that car to the fullest, and I also remember one day in particular, when my dad was in the midst of one of his high manic cycles. He loaded up the bright fire engine red 1963 Plymouth Valiant Convertible with a white cloth top that his brother Vic gave him with a bunch of his best paintings and drove north to San Francisco. We would later discover that, along the way, he gave away all his paintings to the numerous strangers he encountered during his drive up the coast.

When Tony finally returned home from that trip, I vividly remember a day, when I was sixteen, that he had another breakdown. After this one, I drove him to Las Encinas Hospital, where he committed himself once again. At least there, he'd be able take all his medication and get well.

During this period of the late 1960s, he was either in an extremely happy or profoundly depressed state most of the time. There was no longer an "in-between" with him anymore, and the high highs and low lows seemed to be his new normal.

Another mental struggle Tony was facing at the time was that he believed he had split personalities. In April of 1967, he wrote, "What would happen if, let's say, all of a sudden one day God were to send three men who'd previously lived on earth back to live life a second time. Now, for beauty's sake, let's say they were Michelangelo, Da Vinci, and Rembrandt, and they were born as triplets, all into one body on Saint Patrick's Day, March 17th in the year 1909 (which was, of course, his birthday). And God decided he would be called Anthony Ambrose D'Orazi, a man with split personalities."

Tony wrote about another experience he had around this time, when one early morning he called his friend, Ernie Schrank, and asked if he wanted to take a ride to the local art museum. Per usual, Ernie was up for the outing, so they walked the gallery halls and soaked in the artwork together, all while offering commentary along the way, like any two artists would typically do.

As they made their way through the museum, Tony writes, "I noticed a voluptuous blonde woman, standing within an earshot of our conversation, which she seemed to be listening to. As we moved from painting to painting and room to room, she would move with us, so as to hear what we were saying to each other about each painting. Being polite gentlemen, we didn't speak with her, but our eyes couldn't help wandering over to this beautiful woman."

Eventually, as he and Ernie discussed a certain painting, Tony casually turned to her and asked, "What do you think of this one?" The woman answered with a German accent, "I like it very much!" From then on, it became a three-way conversation between the two artists and this beautiful young German woman.

When they finally got finished looking at the very last painting in the gallery, Tony turned to Ernie and said, "Well, it's time to go home, so let's go!" He then asked the woman if she had a ride home, and she didn't since she'd arrived there by bus. At these words, Tony quickly offered her a ride. "We will be glad to take you home!"

Her name was Lilo, and she lived in an apartment near the Los Angeles Memorial Coliseum, right by the University of Southern California. Since Ernie needed to get home sooner than Tony did, he offered to take the bus home from the museum, which he said he didn't mind doing. So, when Tony and Lilo finally arrived at her apartment, she invited him in.

He parked the car and walked her up to her apartment. She explained to him that she wasn't married but for now was living with a college student, who happened to be at school at the time. Upon entering her place, Tony took a seat in a chair, and she offered him a glass of wine, which he graciously accepted. As they both sat there, each with a glass of wine in their hands, Tony tried to think of something appropriate to say but instead blurted out, "Are those things on your chest for real?"

It took Lilo less than a second to pull her beige sweater over her head, and there they were, staring Tony in the face. He recalls audibly gasping and being left speechless. They were quite real and not only that, Tony wrote, "they were perfect specimens, jutting out with firmness and full of life. And in the center of each one was a pretty pink nipple that gave them the right finishing touch. Nature is wonderful!" As Lilo pulled her sweater back down, she said to Tony, "Now don't you get any ideas!" But he did get an idea and asked her if she would be willing to pose nude for a group of his artist friends. She said she could definitely use the extra money, so she agreed.

A few weeks later, Lilo posed for Tony and a few of his artist friends, including Ernie and his other pal, Howard Ball. When their time was done with Lilo, they all paid their share, and she ended up with around twelve dollars, which she was very happy with. That was a good amount of money in those days, and Tony's nude drawing of Lilo would later end up prominently displayed in his Cloud Nine studio behind our house in Eagle Rock.

That wouldn't be the last time Tony would arrange to have Lilo pose for him. "Well, I guess I should tell you about the time I arranged for her to pose nude for me alone," he writes. "I wanted to paint a nude of her, so I set the date. When that day came, as I drove to her apartment, I was confident I would paint a masterpiece." As he entered her apartment complex, the lights were rather low and dim, but he walked straight ahead and fell straight into a swimming pool.

Tony recalled descending into the water and thinking, "Oh well, I'm sinking now, but I'll soon be ascending." As he finally came up for air, he soon realized that there was a big problem—all his art materials were now at the bottom of the pool. At that moment, a teenage boy and his mother came running out after hearing the loud splash outside of their apartment. The boy asked if there was anything he could do to help, to which Tony replied, "Well, I could use some help getting all my art supplies out of the pool." So, the young boy retreated back into his home and soon returned in his swimsuit. After diving in a few times, he was able to retrieve most of Tony's soaked possessions. Drenched from head to toe, Tony gathered his belongings and meekly headed for his car. As it would turn out, Lilo never learned what happened to Tony that night.

As soon as he got into his car, Tony decided to strip to his shorts and turn the heater on full blast. He then drove back home, but as he got close, he realized, "It'd be very difficult to explain how come I was arriving home practically nude on a cold night like this." So, he got an idea. He had an old tuxedo in the garage, which he used to wear back in his vaudeville days. He quietly drove into the driveway, parked his car, and grabbed it. Then, he sneaked back into his car and drove to a nearby real estate office which he had a key to. Barefoot, since his socks were drenched, he went inside, turned on the heater, and called home.

I remember answering the phone and him saying, "David, this is dad," and proceeded to ask me to please bring some socks and

shoes over to the office where he was at. Well, I did, and my father was amazed that I didn't ask him any questions. It is like an unwritten Italian law; you never ask questions to your dad in unusual moments like this. You trust he is doing the right thing and if he wants to share the details of the event with you, then he will. Shortly thereafter, he arrived home, at which point he headed into his studio where he painted late into the evening until all his clothes had dried. "And life went on," he wrote.

After coming to his senses the following day, Tony didn't think he was to blame for the pool incident, so he filed a claim against the apartment owner for not having the area properly lit. He went to court and eventually won a claim for seventy-five dollars.

In the years that followed, I remember one time I was working as a checker at Kory's Market, a grocery store near our home in Highland Park, when this beautiful, voluptuous blonde woman came in to buy some milk. She was perfect from top to bottom, and I had to do a double take because she looked exactly like the painting of the nude woman I'd seen in my father's studio. It was her—Lilo!

I remember that same week I encountered Lilo, my dad stopped by the grocery store to congratulate me on being promoted to a checker. He told me, "Don't work so hard!" Although I never mentioned seeing her to my dad, I'm certain it was her. And that was the last we ever saw of Lilo. Apparently, she didn't like Los Angeles since it didn't have enough culture for her, so she decided to move north to San Francisco, just in time for its historic "Summer of Love."

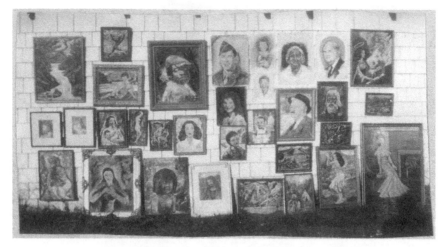

A collection of Tony's painting assembled outside of his Cloud Nine studio in Eagle Rock, California. Many of these he gave away on his drive up the California coast.

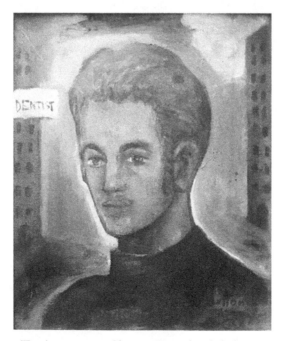

Tony's painting of his son David, while he was preparing for Dental School (1969).

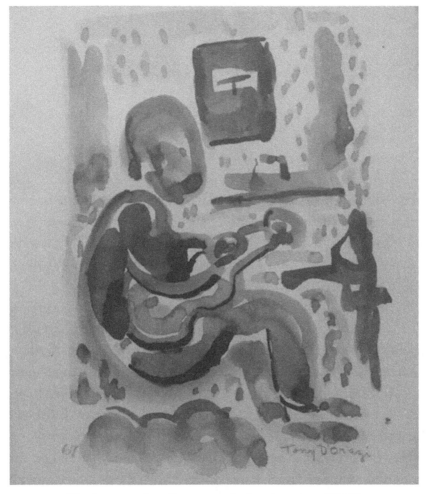

Tony's watercolor of a person playing the guitar (1969).

CHAPTER TWENTY

The Twilight Years

[1968–1973]

In 1968, I went off to college, at which point I began to see my father even less than I had before. I would see him now and then, and most times he seemed to have a good handle of his depression. I remember one occasion when I called him while I was in college, out in Pasadena. After partying too much the night before, I'd slept with my contacts in, and my eyes swelled shut. Since I couldn't see, all I could tell him was that I was at a phone booth on campus but couldn't tell him exactly where it was, since I couldn't see. Without hesitation, my dear old dad came and found me and drove me home.

It was also during these years that my dad finally got back into the TV business and started doing bit parts on all types of TV shows. One of his favorite memories from this period was appearing alongside one of his musical heroes on *The Dean Martin Show* and getting to sit next to him at lunch. Some other notable shows he appeared in were *General Hospital*, *Sanford and Son*, and *All in the Family*.

Then, in 1969, my father attempted to finally take his dream trip to Italy. But unfortunately, while he was stopping in New York on his way to Europe, he entered another manic stage. Tony wrote a letter to his sister, Annie, in Missoula, telling her that he'd tried many times to phone his wife, Treta, but she had left the receiver off

the hook all the time, so he wasn't able to reach her. He implored his sister to get ahold of her and tell her to please leave the receiver on the hook so he could talk to her.

I know for a fact that my mom would often leave the phone off the hook when my dad was in one of his manic states, since he rarely slept during them and wouldn't let her either. His episodes always seemed to happen when my dad was on trips too. But no matter what my father Tony did, my mom always told me that he was the love of her life.

In his closing words to his sister, Tony asked her to pass along a message to Treta: "Tell her I'm fine and that I've decided to come back home instead of continuing on to Italy. I'm going to stay here in New York for a few more days, but it won't hurt for me to talk to her. After all, I am her husband, and I'm away from home, so I just want to know all is well. I am here in room 503 at the hotel. Please tell Treta to call me or drop me a line via airmail. Love, Tony."

He eventually came home from yet another unsuccessful effort to reach Italy and returned to working part-time. He even got his first social security check at this time which made Treta happy. He seemed to be in good health as well, and one day in 1973, he went to see his doctor, Dr. DeJohn, in order to get a complete physical. As a result, they found a cancerous spot on his lung. The doctor said he could operate and clean up the tumor or even completely remove the lung, since he could survive with just one.

Suddenly faced with his own mortality, Tony decided to finally make that "bucket list" trip to Italy that he'd always wanted to take. He still had family there, and he told my mom, Treta, that he was going to visit Rome and other parts of Italy so he could see the work of the great masters with his very own eyes. And this time, he actually made it to Italy, but unfortunately, he would have his final nervous breakdown while he was there. This was his fifth major nervous breakdown, and it would be his last.

During the early stages of the breakdown, he actually kept a daily diary, but as he became more mentally distressed, it came to an end. I actually have a copy of this diary. Normally, he had great handwriting, but over the course of this trip, and as his manic cycle got worse, it changed dramatically until it became mostly scribbles and impossible to read.

However, through various reports and his journal entries, we know that he was able to visit Rome, Venice, and also a town called Bergamo, which is located in the northern Italian Alps, where my wife's relatives lived. While staying with them, Tony scared the family to death by pacing around upstairs where he was staying at all hours of the evening. As it appears, he seemingly never slept while he was there. These Italians had never experienced a mentally ill person like Tony before, and ultimately, I heard this story from my mother-in-law long after the events transpired.

Apparently, while he was in Italy, he'd stopped taking his medication which caused him to descend into his manic state. After he left my relatives' home, he headed to Venice where, as the story goes, he lost what was left of his money at a casino there, which he then got tossed out of. The only way we were able to get Tony back home was through my cousin Macy, who had just graduated from college and was traveling through Europe at the time. Somehow, she was able to contact him through the Red Cross and get him safely back home.

When he arrived back stateside, he was put on Lithium, which had just come out on the market and was recognized for being the best new drug to treat manic depressives. He seemed to get better under its influence, and shortly thereafter, he told my mom, Treta, that he was finally ready to have the operation to remove the cancerous growth from his lung. Before he left for the hospital to have the procedure, he found his best gray suit in the closet and told Treta, "This suit is the one you will bury me in."

The operation was successful, but a week later, a blood clot complicated his recovery which would lead to his passing on October 16, 1974. I remember that night he passed. I received a call at the market I was working at, and I rushed to the hospital to see him one last time. Thankfully, I'd been able to see him in the days leading up to this and was able tell him I loved him before he passed on.

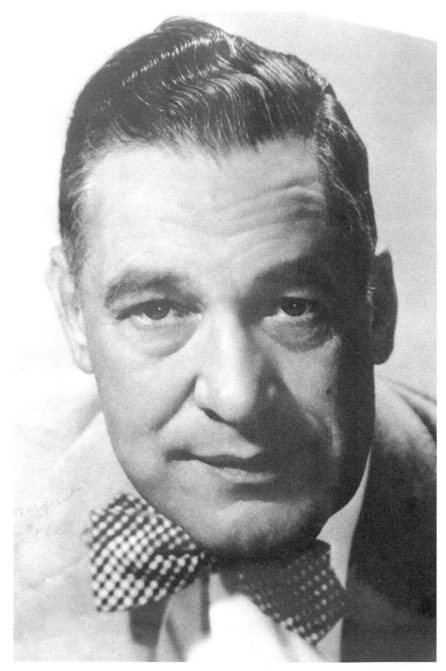

Tony O'Dare's acting headshot (1968).

Tony and his son, David, on his twenty-first birthday (April 1970).

CHAPTER TWENTY-ONE

No Ordinary Artist

[EPILOGUE]

Tony D'Orazi left this plane of existence having accomplished more than most artists who came before him. He was able to achieve his dreams of breaking new ground for artists, both on the radio and television. To some it may seem that his mental troubles were obstacles which didn't allow him to reach his full artistic potential. However, his mental state may have played a role in shaping him into the successful artist that he was.

Despite all the roles he would play in life—as a father, entertainer, and salesman—in between all of them, he was first and foremost, an artist.

ABOUT THE AUTHOR

David F. D'Orazi hails from the Los Angeles suburb of Eagle Rock, which is where he became part of his father Tony's story back in 1949. As the third child of this influential artist-turned radio and television star, who ultimately became a salesman, David proclaims that his father played a huge role in shaping him into the successful salesman that he eventually became.

From his first job delivering newspapers, which his father would often assist him with, to his decades as a record-setting salesman, David now attributes his success to his father. In fact, when he was young, he remembers people telling him that Tony was such an incredible salesman, that he could sell ice to an Eskimo.

Before his mother passed in 2011, she gave David his father's personal journals and scrapbooks which he promised to compile into a book someday in order to immortalize Tony's story. An avid reader, especially of motivational and sales-related books, David combined his memories, along with the contents of the notebooks, to create this biography which he hopes will impact the lives of those who read it, as much as it did his own.

An alumnus of UC Irvine where he earned a biology degree, as well as a master of business from California State University, Los

Angeles, David still resides in the Los Angeles area. There, he continues to avidly sell, read, and now, write. Ultimately, he looks forward to retiring and seeing the Dodgers win another World Series someday.